WILD FAMILY

Seven Stories of Extraordinary Animal Friendship

BHAGAVAN "DOC" ANTLE

WITH JOSHUA M. GREENE

EARTH AWARE
EDITIONS

San Rafael, California

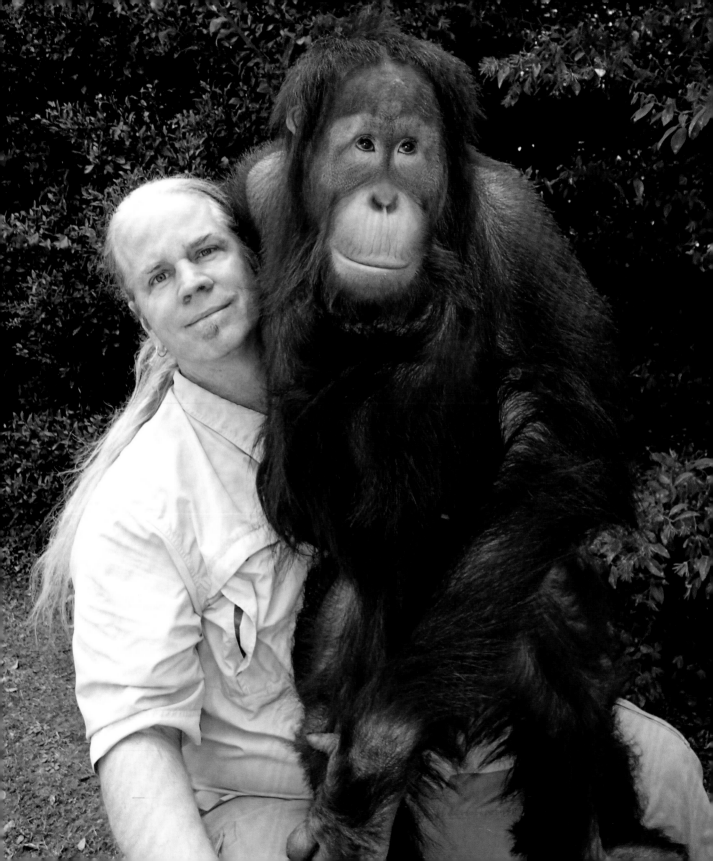

Author's Note

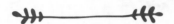

The stories you are about to read reveal amazing interspecies friendships that have blossomed at the Myrtle Beach Safari rare animal preserve in Myrtle Beach, South Carolina. When we designed the physical layout for the Safari, our top priority was to create an environment that would favor animal friendships: a place that would maximize interaction not only between the trainers and the animals but also among the animals themselves.

Our animals become friends because they have no need to compete with each other. They know that their human caregivers will always provide tasty food and treat them with affection. This high level of comfort relieves their survival anxiety and allows them to reveal hidden dimensions of their personality, such as curiosity and friendship. The results are truly inspiring, and my staff and I thought that you, fellow animal lovers, would enjoy reading about our amazing animals and the friendships they have made at the Myrtle Beach Safari.

—BHAGAVAN "DOC" ANTLE, FOUNDER

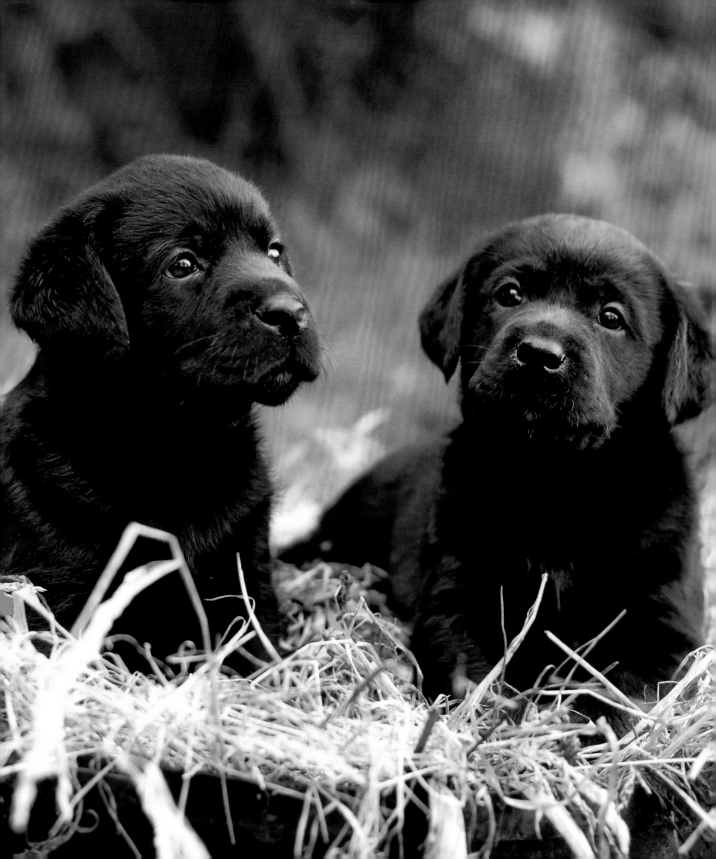

From Flickering Candle to Beacon of Light

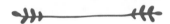

*Friendship helps transform a reluctant black Labrador
into a shining model of community leadership.*

A few years ago, two black Labrador puppies arrived at the Myrtle Beach Safari preserve. George (later renamed Pharos) was the younger of the two, and he wasn't very happy. He would scratch the ground dejectedly, lay his beautiful black head on his paws, and let out a big sigh. Bella, the other black Lab, would try to cheer George up by jumping around and playfully challenging him to swim with her in the river that runs by the preserve grounds. George just sat on the shore and watched the other animals play.

The staff fed George the healthiest food and the tastiest treats, but he never seemed to have an appetite. They took him with them on supply runs, but he didn't seem interested. He preferred to wait outside the store and slowly flop his tail from

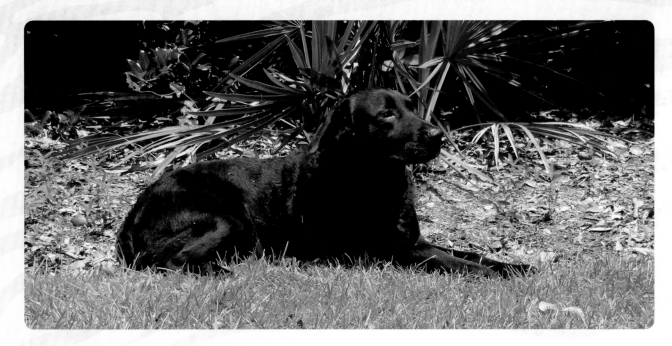

one side to the other until the staff was done shopping. It was not unusual for newly arrived animals at the preserve to adjust slowly, but George showed no signs of adjusting at all.

The animals at the preserve enjoy meeting visitors who come for the tours, which take place from April to October each year. The baby orangutans impress visitors by swinging between oak beams over the walkways. Visitors *ooh* and *ahh* when Bubbles, our African elephant, crushes a watermelon with her massive jaws. Tiger cubs race around an enclosed petting circle, tumbling over one another and sending guests into fits of laughter. Even the preserve's nine-foot-long alligator gets into the act by rearing up like a dragon and agitating the water with her massive tail.

Even though George also met visitors when they came for the tour, he never mixed with them like the other animals. Why was he so sad? We had no idea.

One day, George wandered into the main house and saw something unusual in the kitchen. Two tiny liger cubs were crawling around on the floor, exploring the

room's nooks and crannies and tumbling around the way little kids do. The cubs, named Apollo and Odin, were so small that their caregiver, Moksha Bybee, could hold one in each hand. George sidled up to the cubs, sniffed around them, and then let out a little "Woof!" as though he were saying, "How ya doin'?"

That was the most interest and curiosity we'd seen in him since he arrived at the preserve!

⚶ Ligers ⚶

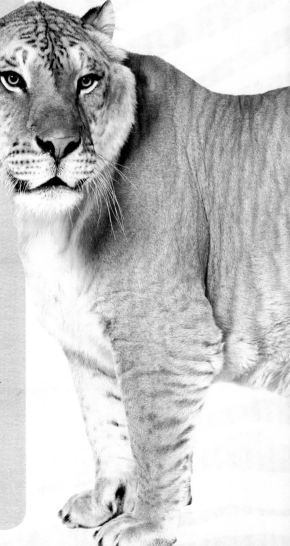

Ligers are the biggest cats in the world. Contrary to popular belief, ligers are not a manmade creation. They result when a male lion and a female tiger like each other enough to mate, something that can happen naturally in the wild. Ligers benefit from "hybrid vigor," meaning they have the combined strengths and attributes of both parents. While tigers might weigh five hundred to six hundred pounds, and lions might weight three hundred to four hundred pounds, ligers can weigh more than nine hundred pounds and stand eleven feet tall on their hind legs.

Ligers are smart, live a long time, and show great resistance to illness and disease. Ligers are also just one of many hybrids that occur in nature. Others include pizzlies (polar bear and grizzly bear hybrids), wholphins (whale and dolphin hybrids), and blynx (bobcat and lynx hybrids). Brian Davis, of the National Human Genome Research Institute, once told our staff that "hybridization is as natural a process as evolution itself. It is part of evolution, part of natural selection."

Nobody really knows how much hybrids contribute to evolution, which is what makes them so exciting. Their story is still unfolding.

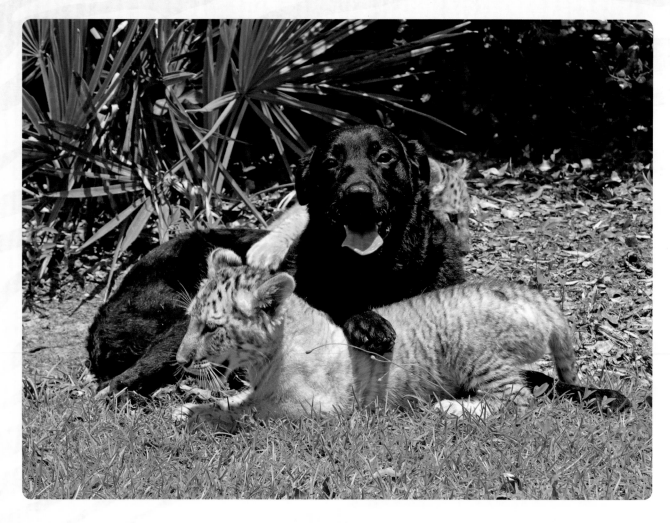

George was no stranger to baby animals, but the liger cubs really seemed to mesmerize him. The cubs were completely unafraid of George and just as curious about him as he was about them, sniffing him up and down and climbing all over him even though he was ten times their size.

By the time Apollo and Odin were one month old, they started anticipating George's next visit. Even before George came into the room, the cubs sensed him coming. They knew his smell, his breath, and the sound of his walk, and they'd run to greet him, climb on his back, and play with him as though he were their surrogate dad.

And that was that! From then on, George had friends and a mission, and his depression went away. Whenever the tiny ligers were brought out, George was always there. He'd nuzzle them, make little *gruff!* sounds as though he were talking with them, and he'd nudge them out the door so he could show them around the grounds. "*Gruff!* Lemme show ya the place!" And off they'd go, a miniature tour group that grew closer and closer as the weeks went by.

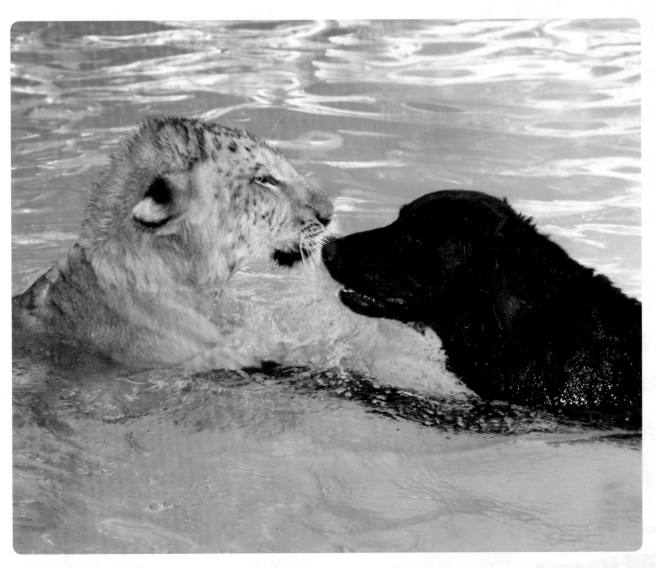

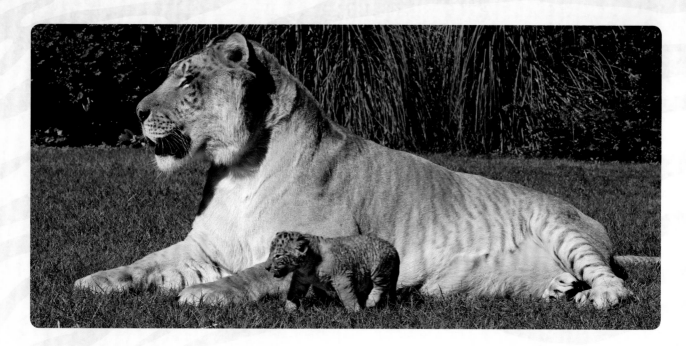

Our caregivers had originally taken charge of the liger cubs because the cubs had been abandoned by their mom. The mother liger had never given birth before. The cubs came out, and she looked at them with bewilderment as though thinking, "I don't know what those are, but I'm glad my stomach feels better." After a few days, she left them to live or die on their own.

Such indifference is not unusual for first-time big-cat moms. A big-cat mother produces tiny babies that weigh only half a pound. Then the mom has to leave them for hours or days at a time while she hunts for food. Consequently, the cubs' survival is at risk during the first several weeks of their lives.

The mother of liger cubs Apollo and Odin didn't have a developed maternal instinct, so our animal caregivers had to step in and hand-raise the cubs.

In this instance, it was black Lab George who stepped into the role of surrogate parent. He cuddled the cubs and kept them comfortable with the warmth of his body. He groomed them and provided companionship by playing with them and

stimulating them with touches and pokes. That physical contact was critical for the cubs' survival and development. George was like a beacon of light, leading the liger cubs to a healthy, happy life.

This unconventional parenting relationship went on for about a year. By the end of their first year, ligers typically weigh nearly five hundred pounds and stretch more than eight feet tall on their hind legs—and Apollo and Odin were no exception. They were enormous! Their idea of play had become dangerous for George. The time had come for the cubs to be separated from their childhood friend.

George watched sadly as the preserve's staff moved the ligers into their new home: an open, wooded habitat with their own cabin and enough space to run and play. From their ten-foot-high observation platform, Apollo and Odin had a spectacular view of the tapirs who lived in the spacious enclosure next to theirs.

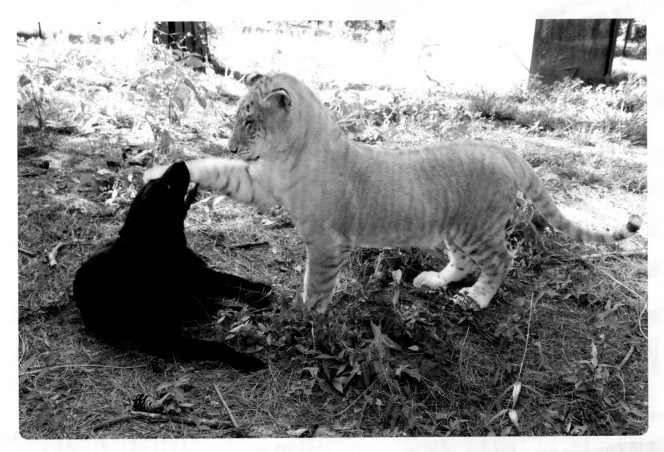

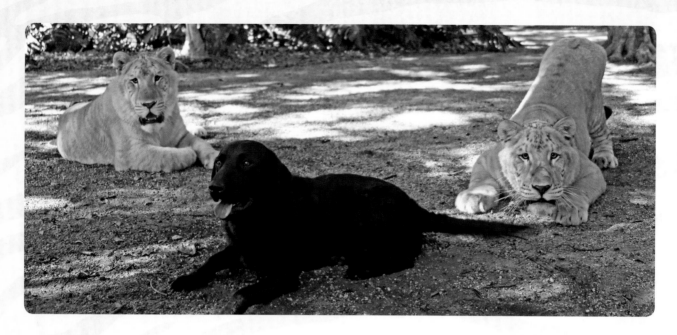

By the time they were one year old, the liger cubs had matured both mentally and physically. Instead of constantly playing, they now focused on mastering their environment. They sat, sometimes for hours on end, surveying the terrain like kings watching over their kingdom. Their behavior shifted from playful to watchful, and they slept much of the day.

When the liger cubs were small, black Lab George could outmaneuver and outrun them. At one year, Apollo and Odin were not yet fully grown, but already their innate power was so great that they could no longer enjoy the kind of playful times with George they had known as cubs.

George had changed, too. Through his relationship with the ligers, his universe had expanded to include friendships with other animals living at the preserve, including monkeys, tigers, and Bubbles the elephant. George's initial shyness and depression had faded, replaced by a healthy curiosity and an interest in mutually rewarding relationships. In fact, his social skills had become so developed that he fell in love with a young panther. George and the panther wandered around the preserve

like an old married couple, happy to be in each other's company. The two have been together a long time now—reminding me, as so often happens while working with these beautiful creatures, that love is not exclusive to humans. George, this beautiful black Labrador, first found love as a caregiver to two liger cubs and then again as a constant companion to a panther.

We renamed George after the island of Pharos, which lies off the coast of Alexandria, Egypt. The island of Pharos is famous for its lighthouse. Over the centuries, the lighthouse beacon has saved the lives of many people lost at sea. Like that beacon, our black Lab has served as a guiding light for liger cubs and other animals at the preserve.

From then on, George was called Pharos.

❧ Animal Ambassadors ❧

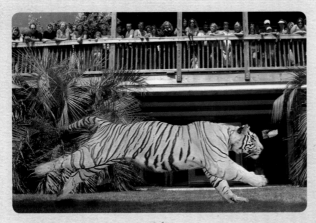

We live in a world threatened by environmental challenges. It is estimated that one-third of all species will go extinct within the next fifty years. There is a very real chance that our grandchildren may never see a live tiger, lion, or any other endangered big cat.

At the Myrtle Beach Safari, we want to encourage our visitors to get involved in wildlife conservation efforts, and one method has proven very effective. We offer visitors the unusual opportunity to meet these beautiful creatures up close. When people get to be near an endangered animal like a golden tabby tiger, a black leopard, or an Alaskan wolf pup, the notion of wildlife takes on a whole new meaning.

The role of "animal ambassadors," or properly trained members of these at-risk species, is to interact with the public and give them that inspiration to get involved. People have a strong, positive emotional reaction to a close encounter with a magnificent animal. At a time when biodiversity is shrinking every day, such interactions and inspiration are gifts we cannot afford to lose.

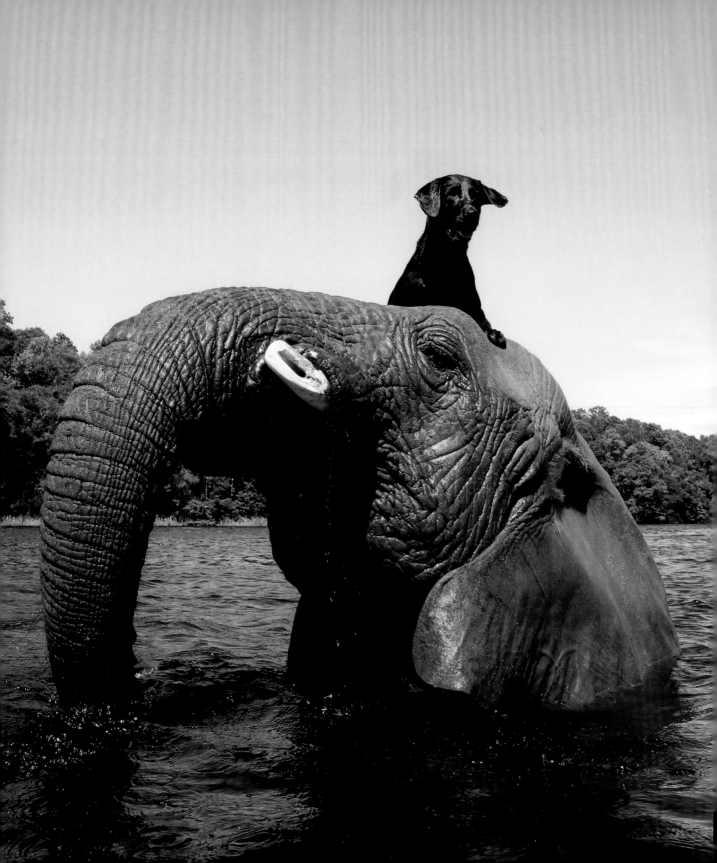

A Heavyweight Friendship

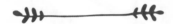

When it comes to choosing friends, elephant Bubbles and black Lab Bella prove that size doesn't matter.

Bubbles, the Safari's African elephant, needed a swimming pool, so we hired a team of workers to construct something unique. One worker, skilled in plastering and laying natural stone, came to work with a six-week-old puppy. There was no facility at the preserve to care for the puppy while her owner worked on the pool, so the worker would tie her to a nearby tree. We had some concerns, as six weeks is almost too young for a pup to be away from its parents. But the pup seemed happy to sit on the sidelines and watch the pool being built.

When we began constructing the pool for Bubbles, there were no standard blueprints to follow. The work was experimental. We'd bring Bubbles down to the construction site and tell the workers, "This is who the pool is for, so don't forget her size, mass, and weight. Make this pool enjoyable for an elephant." The work was done in stages, and each stage had to be tested. So, every day, as workers carved into

the earth and laid the foundation, I walked over to Bubbles's pasture and led her to the construction site. She carefully stepped down into the area where the pool would be, and we calibrated the depth and width and ascent angle to make sure we were on track.

The puppy observed these daily inspections—and Bubbles observed the puppy. Almost from their first encounter, it was obvious that Bubbles was more interested in the puppy than in the pool.

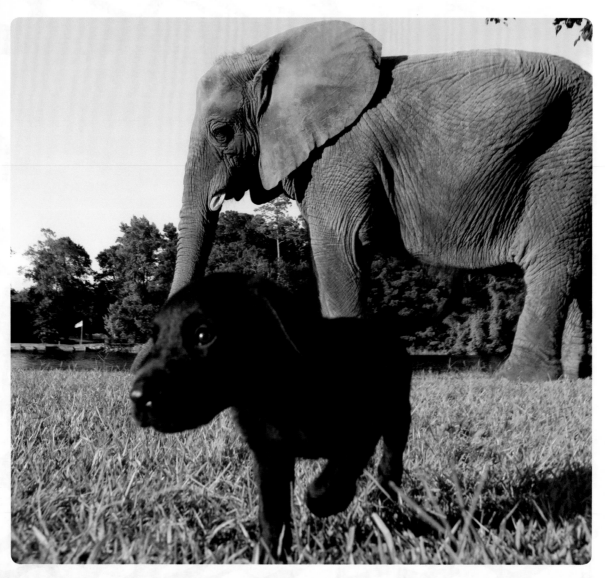

As time went on and as construction continued, the puppy's owner got into some trouble with the law. He became so preoccupied with his problems that sometimes he forgot to take his puppy home at the end of the day. One day when Bubbles was out for her evening exercise, she saw the puppy tied to the tree and went over to investigate. After nosing around the puppy with her trunk, she turned to me and gave me what seemed like a critical look. "Really?" she seemed to say. "Is this how you treat a puppy?"

Bubbles shook her head emphatically, making it clear that keeping this cute puppy tied to a tree was just not acceptable. We untied the puppy, and the two spent hours playing like old friends.

The next day, the puppy's owner did not show up for work. We made a few calls and found out he would not be coming back, and so the staff agreed they would take responsibility for the abandoned puppy. My daughter, Tawny, fell in love with the puppy, and in recognition of how beautiful the puppy was, Tawny named her Bella.

By living with Tawny and the many young cubs staying in Tawny's house, Bella quickly acclimated to being around all sorts of wildlife, but clearly she was developing a special friendship with Bubbles the elephant. Every day, Tawny dropped off Bella at the large enclosure where Bubbles lived, and the two would have a daylong playdate. Visitors marveled at this forty-pound dog frolicking with a nine-thousand-pound elephant.

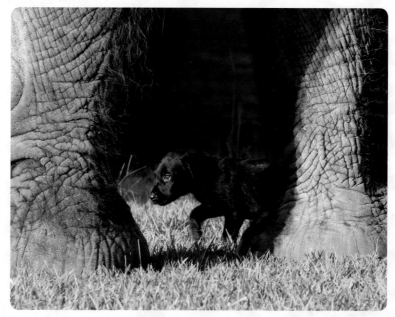

✦ Elephants ✦

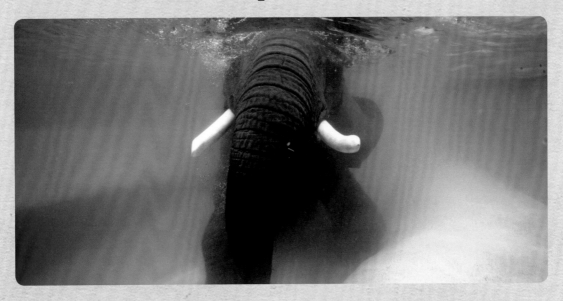

Elephants are exceptionally smart creatures. Their brain, the largest of any land animal, contains almost three hundred billion neurons—three times as many as a human brain. Many of these neurons control the elephant's body, while other neurons account for the elephant's impressive mental skills.

Elephants can identify languages and tell by the tone of people's voices if they pose a danger. They also know how to use tools and can calculate, for example, how to use large blocks as step stools to reach hanging fruit.

One astonishing find is that elephants react to death. When one of them dies, the rest of the herd will express grief by caressing the bones of the dead elephant and standing near the body for hours. Elephants have been observed burying the remains of elephant companions.

An elephant's trunk contains more than forty thousand muscles. That's extraordinary when you realize that an entire human body contains only 639 muscles. The trunk plays a vital role in the elephant's survival. At the first hint of danger, an elephant will raise its trunk, sniff the air, and use its acute sense of smell to determine any reason for concern. The trunk is also used for water storage (a typical trunk can hold about a gallon of water) and for vacuuming up mud and dust, which elephants spray over their bodies to cool off.

Elephants love to play, and Bubbles came up with a game that she plays with children when swimming in the nearby river. With her trunk, she lifts them carefully up onto her massive body, and lets them use her head as a diving board.

Eventually, the pool construction was completed. The shallow end featured a gently descending entrance ramp like a gradually sloping beach, which allowed Bubbles to acclimate to the water at her own pace. At the far end, ten and a half feet deep, the wall was made of five-inch-thick glass. This transparent glass wall allowed visitors to sit at the deep end and enjoy watching Bubbles submerge herself underwater and swim the length of the pool.

Bella attended Bubbles's first test swim. She watched her big lumbering friend wade into the water and, unable to resist joining in on the fun, jumped in as though she and Bubbles had been swimming together all their lives. The ninety-degree water was delightful, and in no time they became a world-class swimming team.

The preserve's land runs along the edge of a magnificent inland river. One day, we took Bubbles for a swim in the river and Bella tagged along. Our neighbors were amazed to see a beautiful black Lab riding atop a nine-foot-tall African elephant. Bubbles lumbered down the road and stepped gingerly down a boat-loading ramp and into the river. Once in the water, Bella and Bubbles invented games. Bubbles bent down and Bella scrambled up onto Bubbles's massive head—an ideal launching pad from which to jump up and catch the balls that Bubbles tossed with her dexterous trunk.

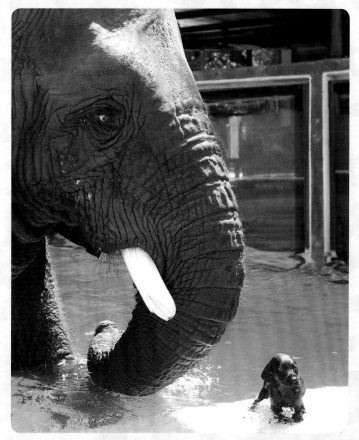

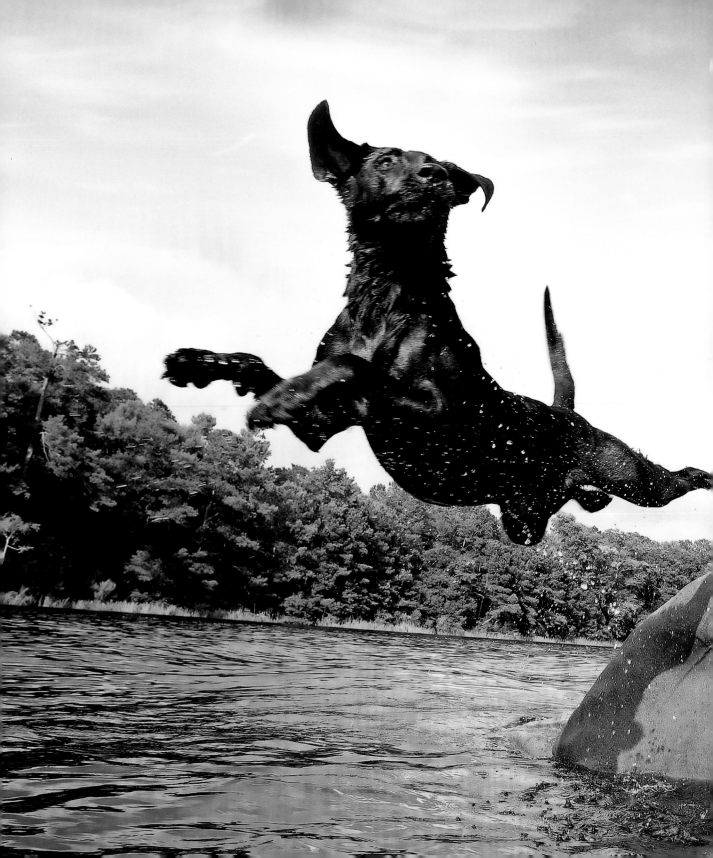

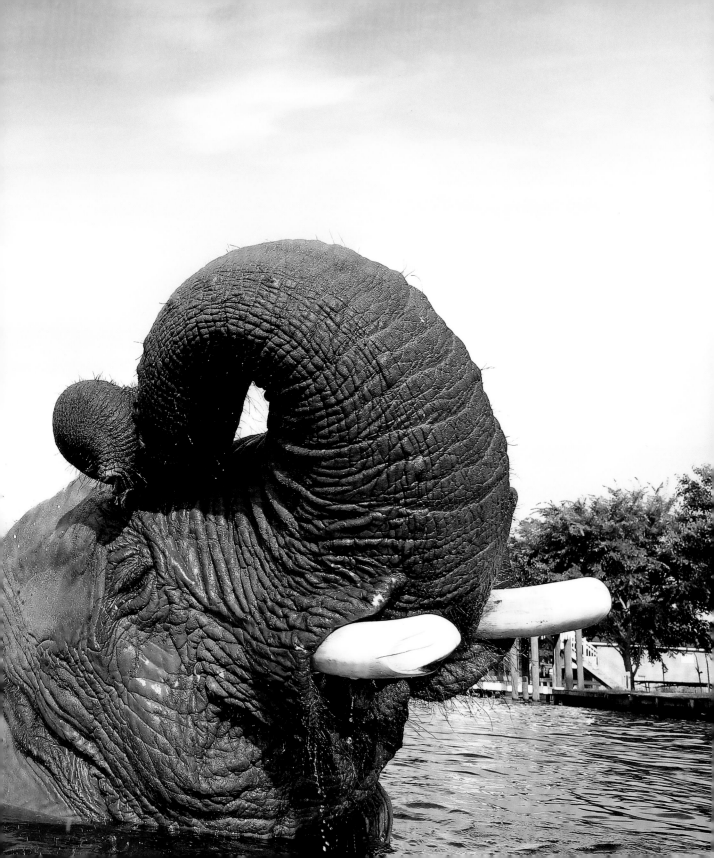

Most human friends will argue from time to time, but I've never seen Bella and Bubbles disagree about anything. There's nothing to fight about! When animals argue, it's usually over territory or food. Bella and Bubbles share both gladly. Bubbles loves cold cereal, but what she loves more is offering some to her friend Bella by holding out her bowl with her trunk and letting Bella eat her fill. They do everything together, including long walks through the forest surrounding the preserve. While Bubbles munches on myrtle trees (from which Myrtle Beach gets its name), Bella explores the forest floor, sniffing at bugs and frogs and barking for Bubbles to come take a look when she finds something particularly interesting. Whenever we wondered where Bella was, the staff knew to walk over to Bubbles's pasture. Unfailingly, there they would find Bella, asleep in the shadow of her nine-thousand-pound buddy.

By instinct or special gift, Bella the pup understood something we would all do well to remember: Don't judge by appearances. Animals, like humans, are perceptive beings capable of conscious thought and feelings. Of course, elephants are exceptional in their ability to grasp complex ideas, understand language, and recognize human emotions. But all animals possess consciousness and are entitled to the same respect we humans deserve. Animals are not "things"; they are sentient individuals who share our planet.

From the beginning of their friendship, it was as though this puppy, Bella, thought, "Here is a living being, like me—maybe bigger, but definitely a lot like me."

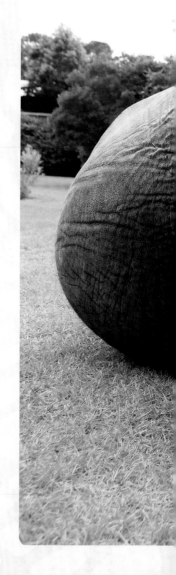

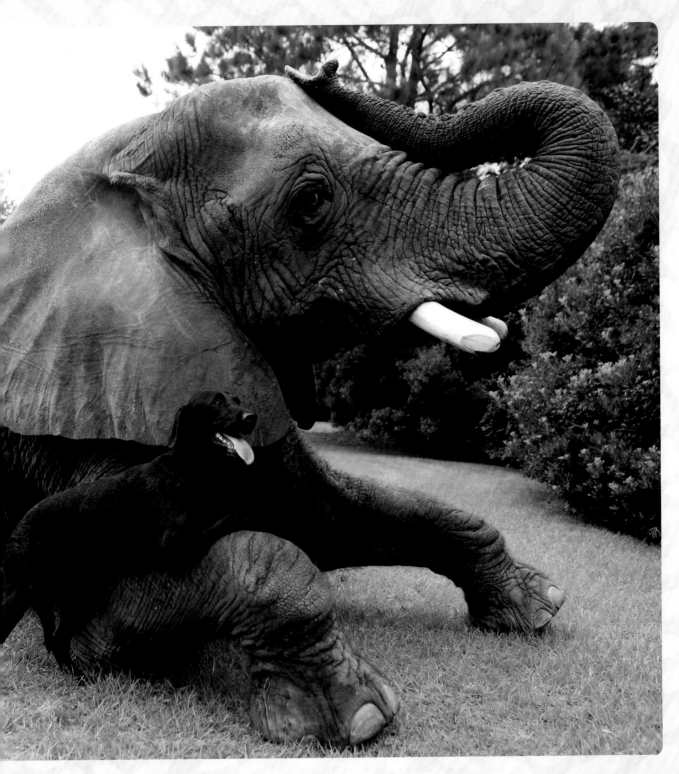

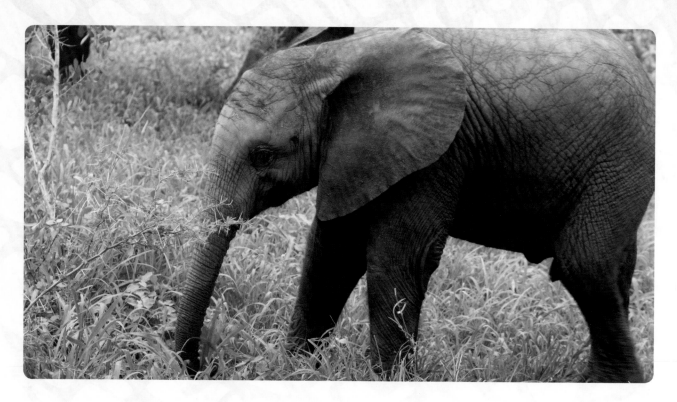

There's something you should know about Bubbles. She was born in Africa around 1981. Ivory poachers killed her parents in 1983. Wildlife rangers brought baby Bubbles to a holding area just a few weeks before I arrived on a tour of African wild-life preserves. The rangers invited me to consider adopting this elephant baby. She was three hundred pounds back then. It took a good deal of time and an immense amount of paperwork, but eventually we were able to bring Bubbles to Myrtle Beach. That was thirty years ago. Now she weighs nine thousand pounds and is the most caring soul you could ever hope to meet.

The friendship between Bella and Bubbles embodies something we often see here at the preserve, something quite remarkable: humanlike consciousness at work in a nonhuman form. All the animals here demonstrate that same almost-human character to varying degrees. When they are young, orangutans and chimps, for example, act in ways that are just like human infants. As they mature, many of them

voluntarily take responsibility for baby animals and behave like caring mothers or fathers. They offer the babies an encouraging pat on the head, do favors for them, and feed them and play with them as though they were babies from their own species.

This sensitivity is found in all kinds of animals, not just dogs and primates. When our visitors interact closely with these creatures, especially those such as tigers, who are generally classified as predators and dangerous to humans, they realize that these animals can be more human than they ever imagined. This is a valuable interaction for everyone involved.

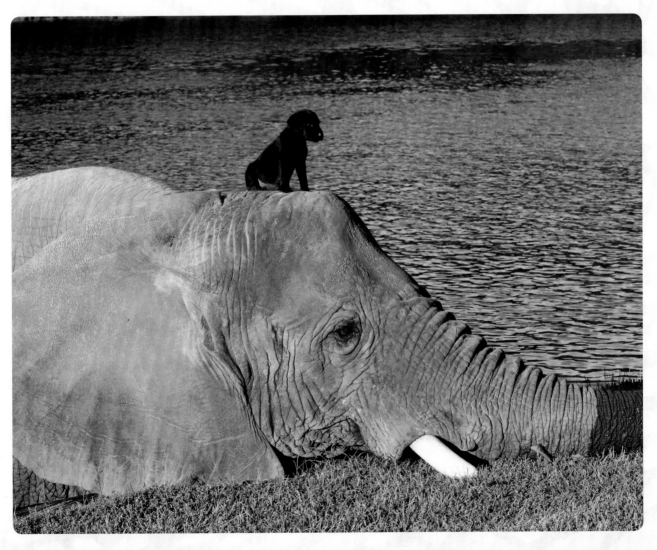

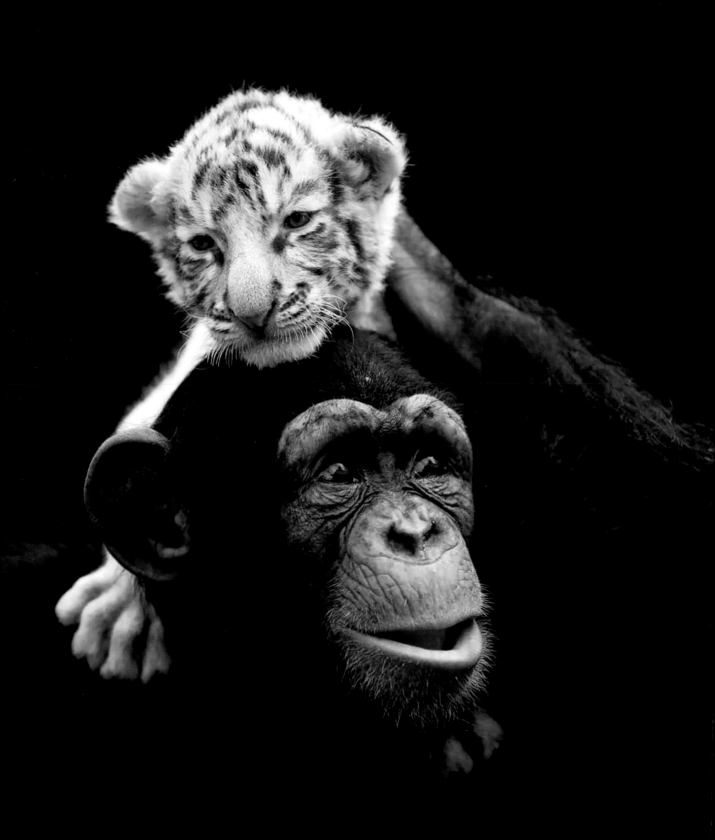

The Chimpanzee Hero
of Hurricane Hanna

*A friendship that started during a disaster became
YouTube's most popular animal story.*

This story begins with Hurricane Hanna, in October 2008. I remember the day well, because when the hurricane hit, every building at the preserve flooded.

China York is the expert here at the Myrtle Beach Safari when it comes to newborns. She has cared for hundreds of baby animals over the years—baby lions, baby tigers, baby gibbons, baby alligators, you name it. China's assistant in caring for the babies is Anjana, a female chimpanzee who was born at the preserve and has been by China's side ever since.

When Anjana was a baby, she followed China around and watched her change the orangutan cubs' diapers, feed the tiger cubs, and carry the baby gibbon around in a sling while doing chores. Eventually, Anjana began pitching in to help. When China bathed baby animals, Anjana waited for the bath to end, then reached into the bathtub, gently lifted the cubs, and handed them to China to dry with a towel.

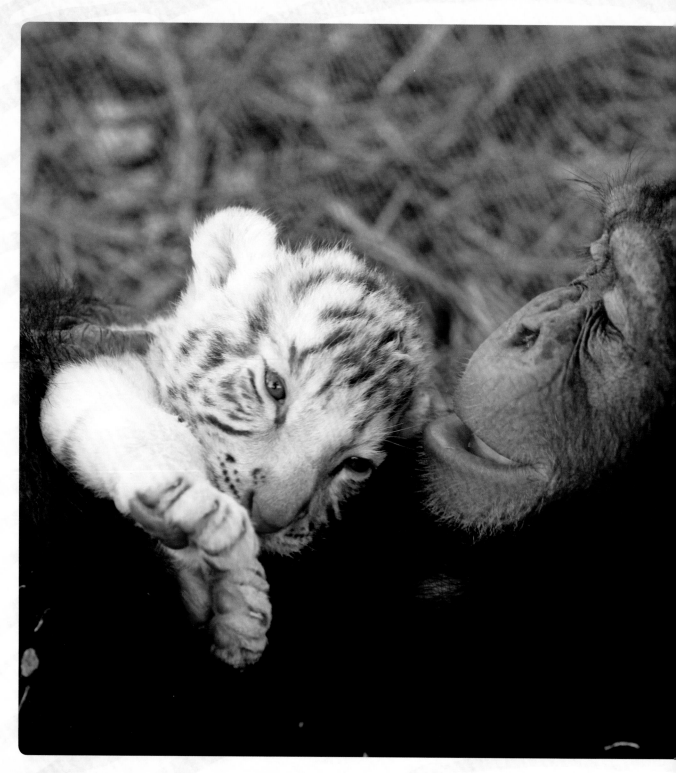

China comforted crying babies by feeding them a bottle of milk. Anjana picked up on that, and as soon as a cub started crying, Anjana fetched a bottle and set it out for China to use. Sometimes China put her finger in a cub's mouth, like a pacifier. Anjana made an experiment by putting her own finger in a cub's mouth. What a surprise when the cub used her finger like a pacifier, too.

Anjana was two and a half years old when television news reports alerted us that Hurricane Hanna would soon hit Myrtle Beach. The staff immediately spread out across the preserve, checking the habitats and making sure the animals had provisions for riding out the storm, however long it might last. China and Anjana were circulating around the grounds in China's golf cart when they heard a tiny squealing from inside the tiger compound. When China and Anjana investigated, they found two baby white tiger cubs who had been born prematurely. The mother tiger had given birth early as a consequence of the dramatic shift in air pressure and her fear of the thunder and lightning.

China needed to get the cubs to a warm, dry place as quickly as possible. They also needed to be fed right away to calm them down. China's house on the preserve served as the baby animal nursery, and it was the natural place to bring the newborn tiger cubs. When China went to retrieve the cubs stranded in the tiger

compound, something startling happened. Anjana held up her hand as if telling China, "I got this." Then Anjana entered the compound, carefully picked up the two cubs, and brought them to China's cart.

China and Anjana drove the cubs back to the nursery and everyone made it inside just as a driving rains began to fall. Together, China and Anjana fed the cubs every three hours, washed them down, rubbed them to increase their circulation, and spoke soothing words. Anjana again imitated China by offering some *ooh-ooh*s of her own.

The staff gives all the animals names, and soon the cubs had theirs: Mitra and Shiva, named after revered sages from ancient India.

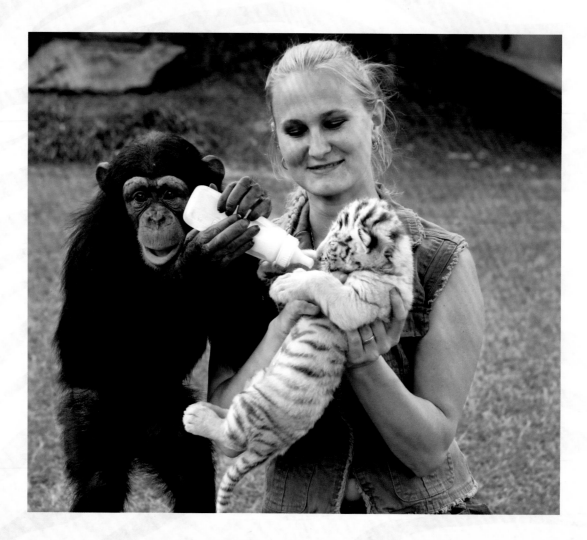

Tigers

Of all the beautiful and exotic creatures who live at the preserve, tigers will always be the main attraction.

At the beginning of the last century, more than one hundred thousand tigers lived in Asia. Since then, 97 percent have been killed; the current population is barely three thousand.

The purpose of the Myrtle Beach Safari is to provide a home for these magnificent endangered animals. Zoos can only do so much: They have neither the space nor the funds to preserve all endangered species, which is why the services of private facilities such as the Myrtle Beach Safari are critical. Because the preserve offers interactive experiences not usually available elsewhere, such as holding a tiger cub, we have seen people walk away transformed by their up-close encounters with these magnificent creatures. As one journal described, "The preserve is like a zoo times a zillion."

Anjana continued to imitate China's care for the tiger cubs. When China played with them and cuddled them, Anjana did the same, putting a protective arm around the cubs and providing the same close contact and affection a mother would give her own offspring. In this case, the mother was a chimp and the offspring tigers. With all that affection from Anjana, the cubs grew up healthy and happy. As the cubs aged, the threesome remained inseparable.

The staff of the preserve watched carefully to make sure Anjana was tender enough to care for cubs that weighed only half a pound—not much bigger than sticks of butter. In addition to such practical concerns, we also asked ourselves whether this was just a case of "monkey see, monkey do" or whether it was something more. Was Anjana merely imitating China's behavior, or was she actually expressing love for the cubs? Were the kisses and hugs real maternal affection, or are such emotions exclusive to humans?

With the passage of time, we became convinced that Anjana was displaying real affection. Now, years later, Anjana weighs more than one hundred pounds, yet she still gives bottles to newborn animals and performs the functions of a gentle care-giver. For example, Anjana walks the baby gibbons around in a cloth carrier, just like a human parent might do with a newborn.

"I think Anjana understood that Mitra and Shiva were calling out for comfort," China says, "and Anjana responded. Anjana understood their cries for help and vol-untarily wanted to provide it. When animals call out for help, it is very much like human babies calling out—a high-register sound that says, 'I need help, I want com-forting.' When Anjana heard the cubs crying out during the hurricane, she wanted to know where those baby tiger cubs were. She was concerned for their safety. It was an amazing display of affection that just touched our hearts."

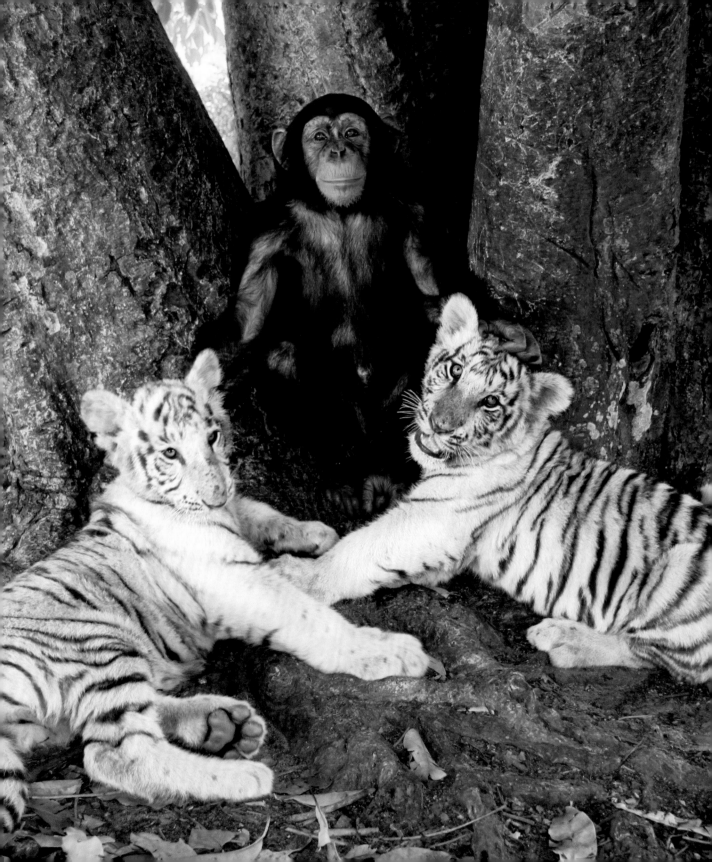

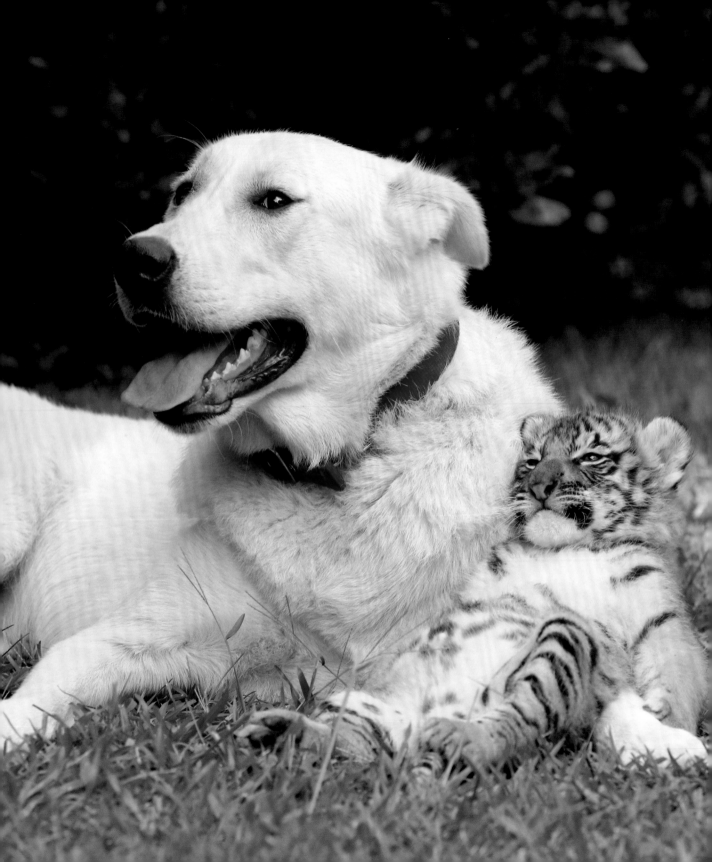

The Mary Poppins of the Animal Kingdom

*Gemma the watchdog embodies the nurturing
qualities of her Akbash heritage.*

Gemma, the preserve's Akbash dog, lives with Rajani Ferrante, the preserve's assistant director. The house they share has become a nursery for many of the big cats born at the preserve, and Gemma loves serving as their nanny. Not long ago, Gemma helped raise a litter of tiger cubs, but it was clear to everyone observing her that Gemma had special affection for one beautiful standard Bengal tiger cub named Veda. When Veda was still a baby, we would frequently find her asleep between Gemma's paws.

Baby Veda loved using Gemma like a jungle gym, climbing on her back and over her head and running between her legs. Despite Veda's rambunctious nature, Gemma never deviated from serving as a patient, caring nanny.

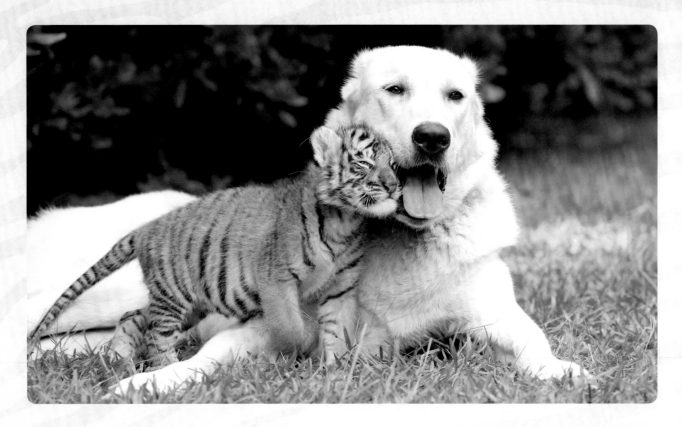

Originally, Gemma came to us as a cub from a zoo run by friends in Virginia. It was a generous gesture since Akbash are rare and useful both for guarding a private facility such as ours from intruders and for raising cubs.

Most dogs aren't versatile enough to assist in raising cubs from other species. Akbash are different. For thousands of years, herdsmen along the Alps and Pyrenees mountain ranges have used Akbash to help herd goats and sheep. Over such a long period, that caregiving ability has become part of the Akbash personality. In Gemma's case, instead of goats and sheep, she was given responsibility for baby tigers, lynx, pumas, chimpanzees, and a dozen other species.

Gemma was able to discern, for example, that the lynx enjoyed social play and could handle a little roughhousing, while tiger cubs like Veda wanted to be loved and reassured. It's unusual for a dog to intuit such specific character differences between different species, but for Gemma, that sensitivity was inbred.

⊹ Akbash ⊹

Akbash are short-haired close relatives of the Pyrenean Mountain Dog (known as the Great Pyrenees in North America). People often mistake the Akbash for a herding dog, but Akbash dogs do not chase or round up livestock the way herding dogs like border collies do. An Akbash will act decisively against predators, yet when properly raised they will also be gentle enough to keep company with newborns.

In their role as livestock guardian dogs, Akbash can spend long hours just lounging with flocks or herds. Consequently, some people think of the Akbash as a low-energy breed, when in reality they are always observing and taking in what is happening around them. When patrolling the perimeters of their territory, Akbash will listen for unusual sounds, sniff out unique scents, and look carefully for suspicious movement. When protecting their charges, Akbash dogs are focused and vigilant. The Akbash is not the first choice for a companion dog, since they have little interest in the usual dog games such as chasing or fetching. The Akbash is a working breed, happiest when given tasks such as guarding or patrolling.

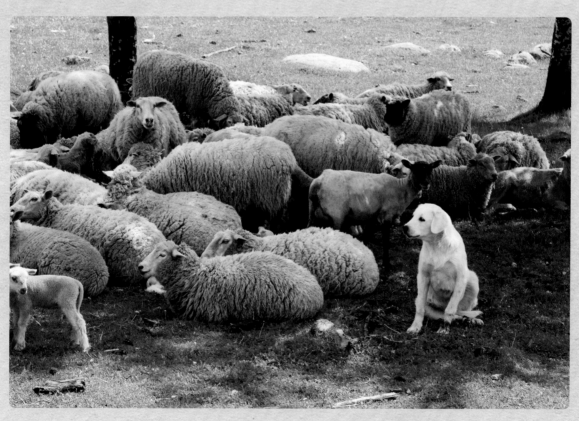

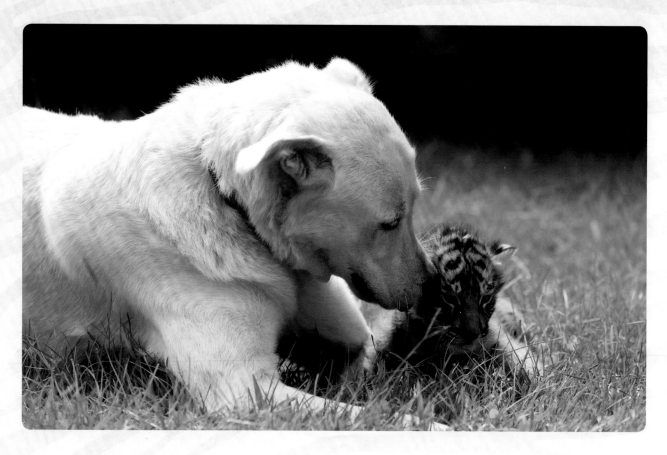

We sometimes think of Gemma as a four-legged Mary Poppins who puts the well-being of her brood above all else. She can sense danger and knows how to keep her charges in line without being nasty about it.

Gemma seems to understand the benefit of being nice while being attentive. She can look at an animal and know its intentions. If newcomers try to be dominant or throw their weight around, Gemma will put them in their place with growls or by showing her teeth. I remember two tiger cubs who would not stop fighting. Gemma played sheriff. She slid in between the two cubs, rubbed each one with her nose, and settled down with one cub on each side. Gemma was like a big, warm blanket that calmed them down.

We ultimately count on Gemma to teach the young ones proper Myrtle Beach Safari behavior. For Gemma, such mediation skills come naturally.

As tiger cub Veda grew older, Akbash Gemma helped teach her to walk on a leash and swim in the preserve's heated pool. We even watched in amazement as Gemma taught Veda to walk across the preserve's elevated rope bridge, which swings in the wind and takes practice to cross. Someday soon, Veda will be too big for a nanny, but the staff of the preserve has a hunch that by then, Gemma will be raising Veda's children and serving a new generation of tiger cubs.

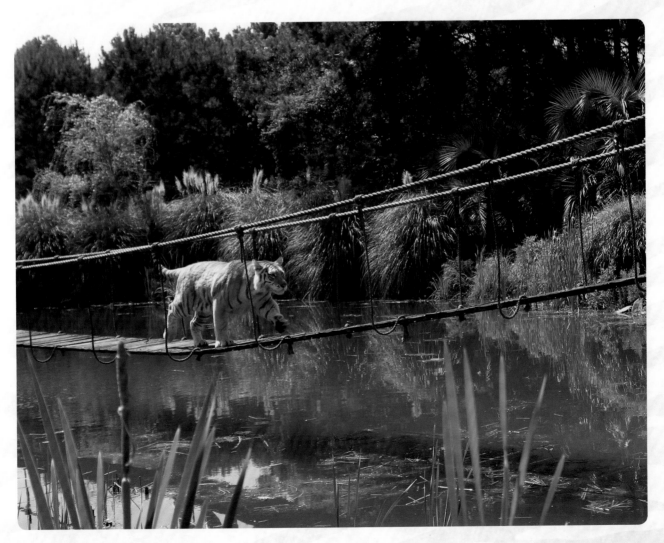

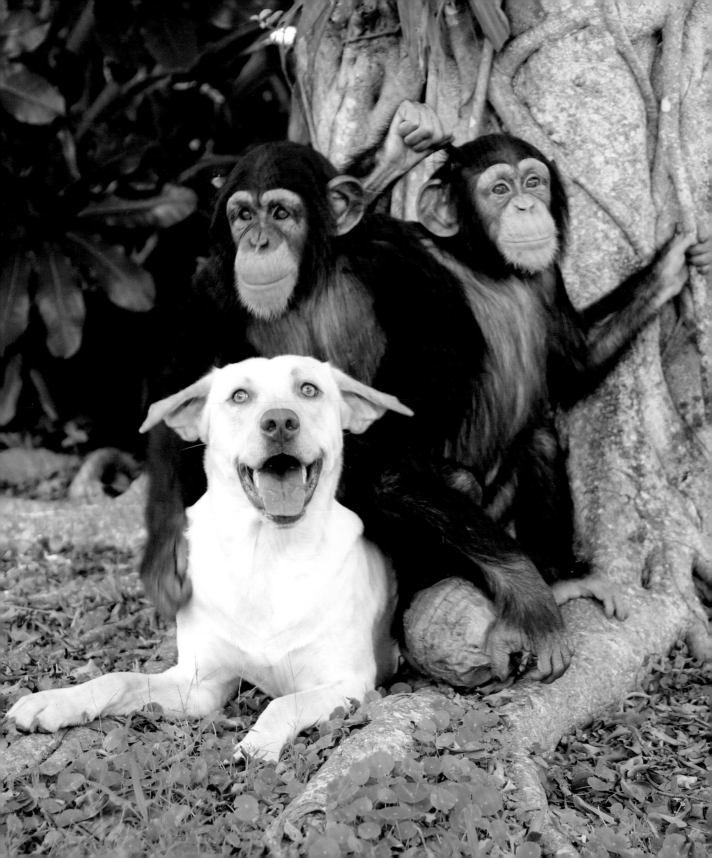

Animal Escapades

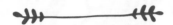

Yellow Lab Buddha and his chimp buddies Vali and Sugriva have created an act straight out of Vaudeville.

Chimpanzees more than live up to their reputation as wacky, zany, fun-loving creatures. They bounce around like rubber balls, romp about like rambunctious toddlers, and invent slapstick routines that send the staff of the preserve into laughing fits. We were surprised when Buddha, a yellow Lab pup living at our Miami location, turned out to have as much of a silly side as his two chimp friends.

Buddha is my son Kody's dog. Buddha first met the chimps when they were little. Vali was nine months old when he came to stay at Kody's house, and Sugriva was only three months old when he moved in a short time later. We are often asked to take in animals. Some are liberated from a harmful situation and need a new home. Others may have been born in another facility that does not have enough room to care for them. Vali and Sugriva had not been abused, but their owner felt they would have a better life with the Myrtle Beach Safari.

When little monkeys arrive at the preserve, Kody's place is their first home. Kody's house is built inside the preserve land and is outfitted as an animal care facility. The doors are made of steel and shut automatically, the cabinets have numbered locks, and pet entrances are covered with metal swinging doors in place of the usual flapping plastic. The backyard features a swing set and a small pool for use by monkeys. The house is more like an animal resort than a family dwelling.

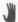

"If someone is looking for an animal to be a companion for their pet," Kody says, "most people would get the same species. But Buddha was smart and responsive to the chimps, and they were having a good time together. From the first day they met, they started chasing one another around the house, they ate at the same time, slept together in the same bed—and when it came to mischief, it's like the three of them had gone to the same comedy school. I've seen a lot of cross-species friendships here at the preserve, but this was a whole other level of bromance."

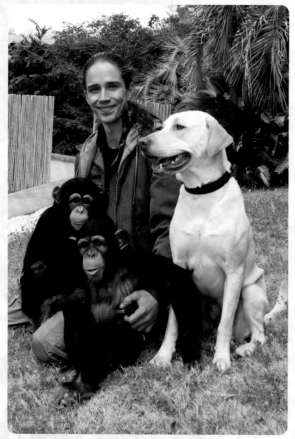

The slapstick started innocently enough when Kody taught the chimps to feed Buddha. Kody pointed to one of Buddha's favorite foods—a banana—sitting on a table, and Sugriva picked it up and held it out to Buddha in a friendly game of "Feed the Dog." Then Sugriva figured out he could pretend to hand over the food and then pull it away at the last second, in an edgier game of "Tease the Dog." Things escalated when the chimp Sugriva jumped up on the table, took a big

bite out of the banana, and dangled the remainder over Buddha's head, just beyond snapping range. "Tease the Dog" had now become "Make the Dog Nuts."

Vali was the older of the two chimps. He watched this game a few times—little Sugriva munching on Buddha's treats and teasing the dog with whatever was left over—and decided to up the ante.

There are coconut trees on the preserve's property in Miami. The preserve's dogs are crazy for coconuts, and one game we play with them is "Fetch the Coconut." We toss a coconut into the bushes, and the dogs rush into the bushes, find the coconut, and come tearing back with it in their jaws. Well, anything the dogs are doing, the monkeys want in on. But Vali and Sugriva weren't as quick as Buddha to fetch a coconut, and the chimps wanted their chance. So, in one round, when Buddha ran ahead and came trotting back with the coconut, Vali and Sugriva grabbed it out of his mouth and ran off. "Fetch the Coconut" had intensified into "Steal the Coconut."

That led to the next version of the game: Buddha had to guess which chimp had the coconut, then go chasing after him to grab it back. Imagine one-year-old chimpanzee Vali, running downfield, screaming his lungs out as he is being chased by this powerful yellow Lab. Vali did a one-handed football carry, straight-armed Buddha with the other hand, and finally scampered up a tree before Buddha could snatch it back.

Then Sugriva did his chimp brother one better. He jumped up into the tree, grabbed the coconut from Vali, looped his legs around a branch, and started swinging back and forth, dangling the coconut and daring Buddha to snatch it back. By now, the coconut was a shredded mess, more like an organic rag; the chimps were swinging upside down, and Buddha was going gradually nuts, barking and jumping and desperately trying to retrieve his shredded coconut. But whenever he got too close, the chimp holding the shredded coconut tossed it to the other one. Sometimes, just to keep things moving along, the chimp with the coconut threw it onto the ground—close enough that the first chimp could jump down, grab it, and jump back into the tree before Buddha clamped his jaws on the prize.

The game had now become "Make the Dog Crazy." It was all the staff could do to keep the animals from leaping over a fence in their enthusiasm.

After a few hours of this zaniness, when Buddha, Vali, Sugriva, and everyone on staff were completely exhausted, it was time for a swim.

The chimps were not into it. Buddha loves the water, like most dogs. Chimpanzees don't. Evolution has taught them to avoid water. That's where croco-

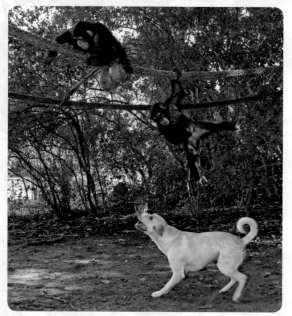

diles live. That's where danger lurks. So, it took Sugriva and Vali a little time to acclimate to being in water.

At first, Kody bathed them in a shallow tub with just a little water in it. Nothing threatening there: no crocs in the bathtub. Later, we built them a big customized tub and turned on the faucets to let the water level rise slowly. We put toys in the tub for them to play with and tossed treats into the water so that they had to get their arms and head wet to retrieve them.

The first time Buddha jumped in the pool, Sugriva went bonkers, jumping up and down, waving his arms, signaling to Buddha, "Get out of there! That's dangerous!" Buddha obliged and came back out. Then he jumped in again, and now it was Vali's turn to go ape, running up and down the side of pool, trying to screech sense into Buddha's head about the dangers of water. And Buddha, good buddy that he was, obliged and came wading back out.

By the third time Buddha dove into the water, the chimps figured he knew something they didn't, and they dipped their feet in. At this point, the pool was just

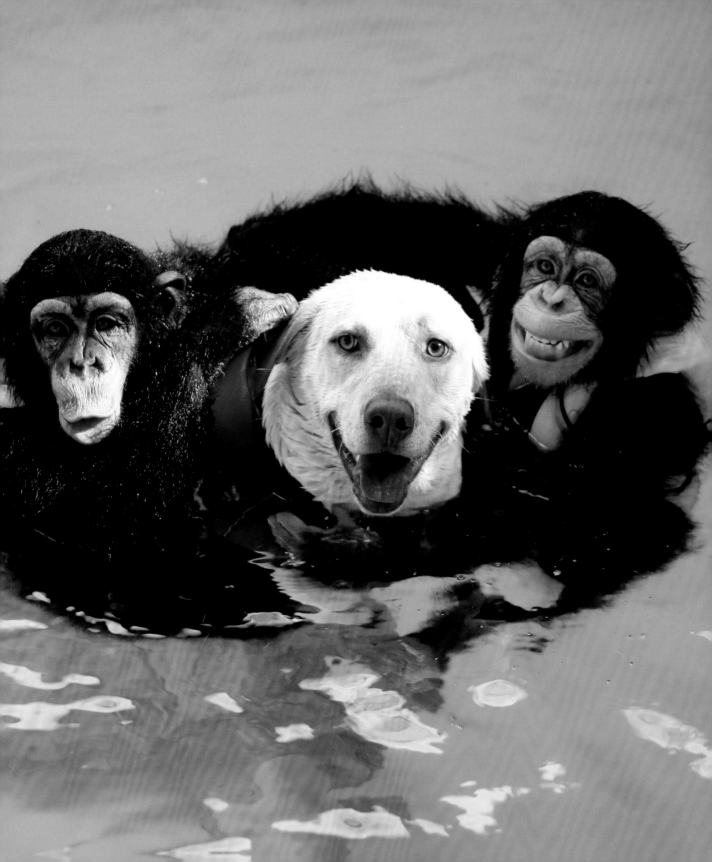

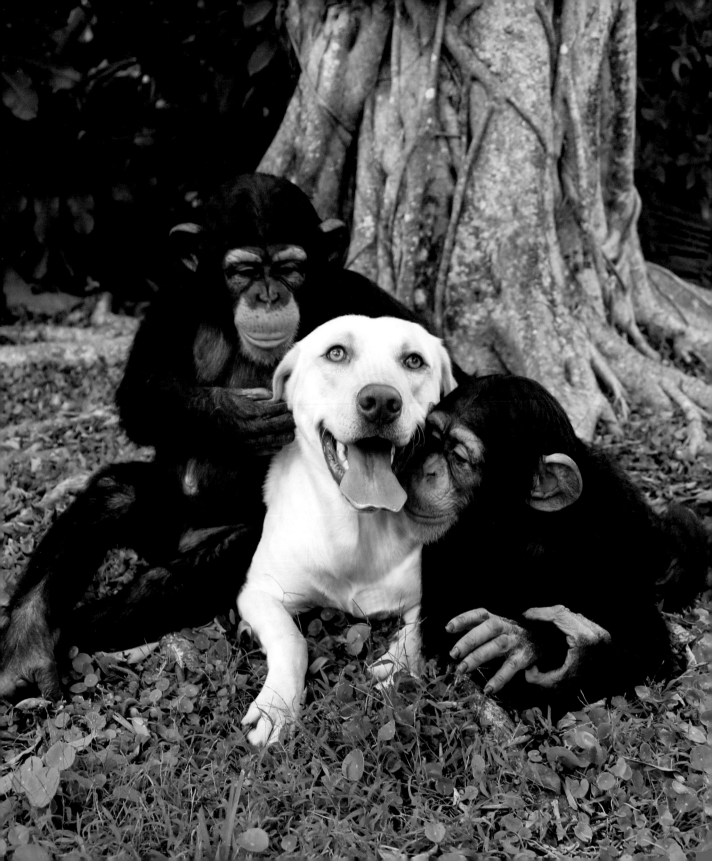

a big bathtub and not as threatening as before. The best part was watching Buddha dive headfirst into the pool for a ball.

Sugriva and Vali looked at each other and must have thought, "Well, it must be safe if he can do it." So they dove in! They stayed in the water for hours, jumping around and diving in like they'd been doing it all their lives. They still do, the three of them, every warm-weather day.

It's been several years since those first brave dives into the pool. These days, Sugriva and Vali take long walks with Buddha. They hang from his back and hold onto his collar as they stroll along. Buddha is older now, larger and less agile. The monkeys give him a hand, helping him get into the golf cart or tossing a ball for him to fetch. Previously, he was their master. Now in his old age, the monkeys are his caregivers. The roles have reversed, but the love between them is stronger than ever.

The dog and his chimp friends have grown mellow. Age has tamped down a lot of their youthful, headstrong exuberance, and these days, when Buddha sees the chimps coming through Kody's door, they greet one another with laid-back hoots and mellow woofs: "Hey, wassup? What's going on?" If Buddha stays outside for too long, the chimps go to the window, pull aside the curtains, and look around to see what their dog buddy is doing.

There isn't any moral to this story, nothing to embroider on a pillow or hang over a fireplace. The antics of the Lab and his chimp buddies are just that: friends enjoying time together—except that theirs was a friendship previously judged to be scientifically illogical. Living at the preserve in comfort and security, creatures who would otherwise have nothing but suspicion about each other's motives are the best of friends. People might take a lesson or two from that.

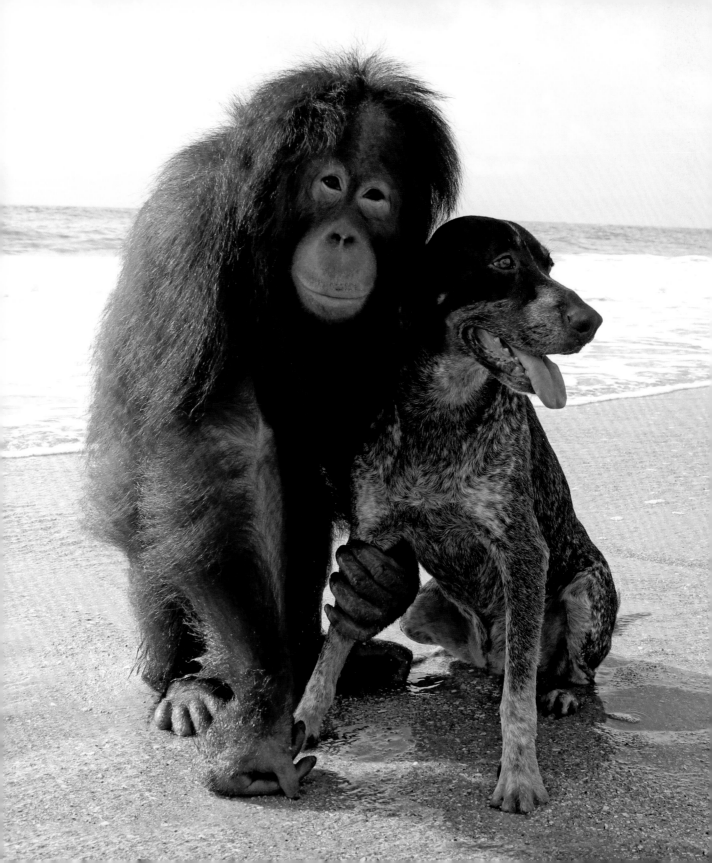

Charity Begins
at Home

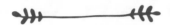

*Orangutan Suryia and his best friend, hunting dog
Roscoe, use their wealth to save wildlife habitats.*

The orangutans living at the Myrtle Beach Safari want for nothing. They are completely comfortable. That's not a normal situation. In the wild, every day is a struggle for orangutans. They wake up, and the first thing they have to do is find food and water. They also have to defend their territory against intruders, both animal and human. Only after they have met those minimum necessities can they think about the next problem: finding a mate and reproducing. Then, after they have mated and had offspring, they can worry about getting up the next day and starting over again.

At the preserve, we've taken these struggles out of the equation. Not only the orangutans but all the animals here know they do not need to fear death from predators. They do not need to worry about finding food or shelter. They do not need to

worry about finding a potential partner. Since their needs are met, they can relax and think about other things—like making friends.

Our orangutan Suryia and his best friend, the hunting dog Roscoe, have gotten a lot of attention. They have appeared on the National Geographic Channel, they have been featured in books on animal friendships, and their YouTube videos are widely watched—in the hundreds of millions of views. When I think about all the attention they get, I'm reminded of an achievement we don't usually associate with wildlife: wealth. From all the media attention and sales of their books, Suryia and Roscoe have become rich. Here's how it happened.

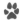

One day, Suryia the orangutan, Moksha our wildlife conservationist, Bubbles the elephant, and I were down at the waterway when a bluetick coonhound stumbled

onto the scene. As soon as Suryia saw the dog, he ran over, hugged him, and started playing with him as though they were old friends. Dogs are usually scared of primates, but these two took to each other straightaway.

The hound looked really thin, weak, and lost, so we took him in. The hound was wearing a dog collar with a notice riveted to it: "If you find this dog, call this number." We called, and a voice at the other end of the phone said, "Oh yeah, that guy moved away." That's how Roscoe ended up moving into our preserve.

Suryia and Roscoe acted like old buddies and spent hours each day rolling around, swimming, and playing like kids. Suryia took Roscoe for walks around the preserve and even fed him some of his monkey biscuits. When they felt a little lazy, they hitched a ride on the back of Bubbles the elephant.

Rob Johnson, our resident scholar-photographer, started taking pictures of the two friends at play. Then he shot some videos and posted them on YouTube. The number of viewers climbed steadily, from a few hundred to a thousand to more than one million. Next thing we knew, television producers came calling, and a publisher offered to create a picture book of their friendship. From all this activity, money started coming in.

Staff at the preserve figured the money belonged to Suryia and Roscoe and came to a conclusion about how it should be spent. Everyone agreed: The money should go to help save orangutan habitats. The greatest danger to those habitats comes from the harvesting of palm oil.

⚘ Palm Oil ⚘

Palm oil is a type of edible vegetable oil present in baked goods, shampoos, cosmetics, cleaning agents, washing detergents, and toothpaste, among other household items. With rare exceptions, palm oil is not harvested using sustainable measures, and consequently the palm oil industry is linked to major issues, such as deforestation, habitat degradation, climate change, animal cruelty, and indigenous rights abuses.

Most palm oil comes from Indonesia and Malaysia. To produce it, land and forests are stripped of all natural growth to make way for palm plantations. According to the World Wildlife Fund, an area the size equivalent of three hundred football fields is cleared from the rain forest every hour of every day to make way for palm oil production. The rain forest is home to a wide range of endangered species, and this large-scale deforestation is pushing many of these species into extinction. Currently, one-third of all mammals in Indonesia are considered critically endangered as a consequence of palm oil production.

One animal particularly endangered by palm oil is the orangutan. In Borneo and Sumatra, the two islands where orangutans live in the wild, more than 90 percent of orangutan habitats have been destroyed in the past twenty years. People can help save the habitats of orangutans by avoiding products that contain palm oil, such as certain brands of ice cream, processed foods, margarine, and soaps.

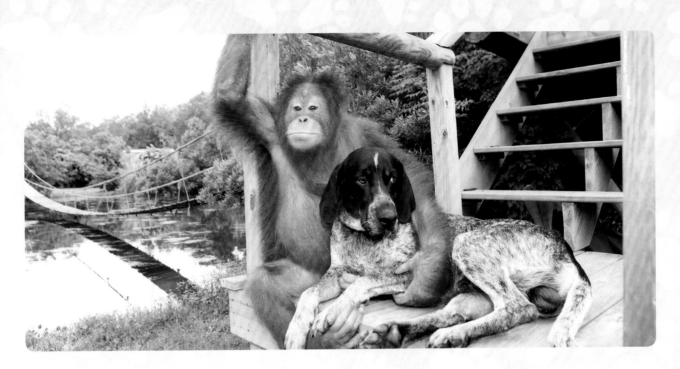

Suryia and Roscoe have been together now for more than a decade. They appear quite the odd couple, sitting and watching the world go by, just happy to be together lounging in the shade. But they have a message and a cause: Avoid palm oil, which is in many products, including most candy and other junk food. Suryia and Roscoe contribute to other worthy causes. From the sales of their picture book and other sources of revenue, Suryia and Roscoe have donated to date a total of $70,000, primarily to local Humane Society chapters.

Orangutans usually follow a simple rule: "What's mine is mine, and what's yours is also mine." Suryia didn't buy that. He has always loved sharing everything. If you offer him a piece of fruit, he bites it in half and offers one half back to you. Other primates I've worked with will pretend to offer you something, but they're just teasing and never actually give it. Suryia is an example for us all, a compassionate creature who saw a dog in need and helped give the dog a home, friends, and a reason to live.

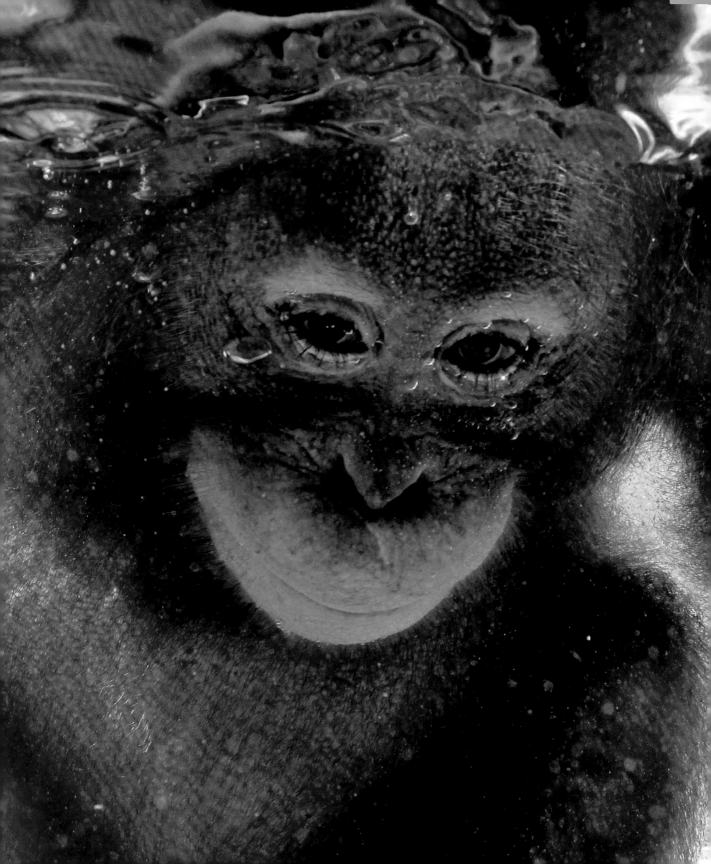

Amazing Aquatic Apes

Humans swim, apes don't—until now.

Most scientists agree: Orangutans, chimps, and other apes such as gibbons and gorillas are unable to swim. Yet here at the Myrtle Beach Safari, orangutans and chimpanzees disprove that theory—not only by swimming but also by diving, playing in the water, and even holding their breath and swimming underwater for long distances. Here's a story about three apes living at the preserve and the amazing things they can do in the water.

As a young orangutan, Suryia spent his days outside playing with his human and animals friends. At night, he slept in his caregiver Moksha's house. His evening routine included taking a bath, which was his first introduction to being in water. He had so much fun in the tub that he and Moksha would sit in the water for hours soaking and playing.

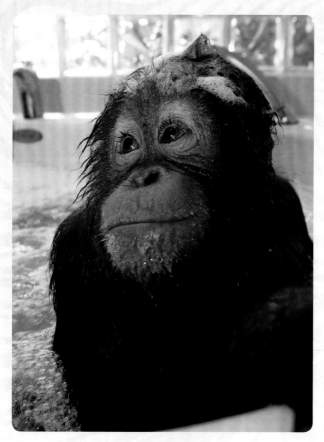

One day, I suggested to Moksha that she put a life jacket on Suryia and see what he thought about going in the pool. With the vest keeping him afloat, Suryia paddled along, not needing anyone's help as he swam from side to side.

Suryia grew up with a lot of animals who did better in water than he did. In the pool, he watched his hound dog friend, Roscoe, swimming without a vest. He watched other animals including otters, tapirs, and tigers swimming without a vest, and two things happened. Suryia became jealous of the other animals having so much fun without a vest, and he became inspired to try it for himself. One day, Suryia took off his vest, tossed it aside, and jumped into the pool. He was a natural! He swam laps from one end of the pool to the other perfectly.

Like all orangutans, Suryia is arboreal, meaning he can swing in trees from branch to branch. As a result, his arms and upper body are very developed. Those big arms made long, strong strokes that kept him afloat without a vest. He was so good at swimming that he began teaching other apes how to swim.

Suryia's first student was the orangutan Hanuman. One day, Hanuman watched in amazement as Suryia jumped in the pool and swam as though it were the most natural thing in the world for a primate to do. Hanuman was a particularly fast learner. He studied Suryia's technique and quickly began imitating him, first wading

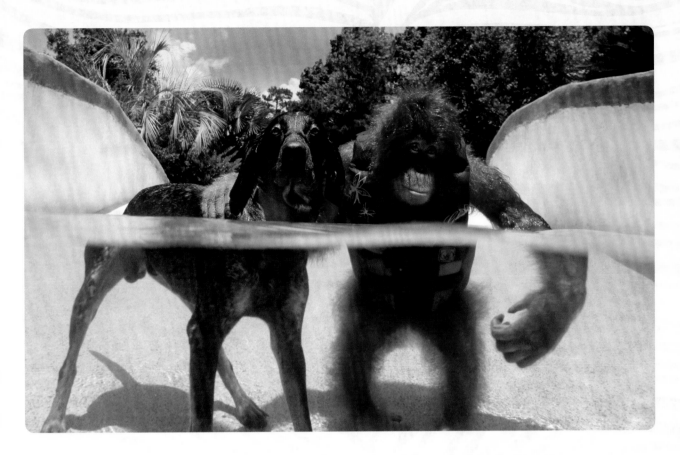

into the pool, then launching out into the water. It didn't take long before Hanuman was even more accomplished than Suryia at holding his breath underwater.

Hanuman also showed himself to be a champion diver. At first, he held onto Moksha when she dove off the edge of the pool. Then he began diving on his own. One day, he happened to find a loose tile on the deck of the pool. To the chagrin of the staff, he tugged at it with his giant sausage-size orangutan fingers and popped it out. Then he threw the tile into the middle of the ten-foot-deep pool, where it quickly sank to the bottom. Hanuman dove headfirst into the water and walked along the bottom of the pool until he reached the tile. Then he grabbed the tile and surfaced with it in his hand.

Basically, aquanaut Hanuman had invented his own watersport, throwing and retrieving the tile dozens of times, without ever growing bored.

❖ Arm-Swinging (Brachiation) ❖

Primates such as gibbons and orangutans swing from one tree branch to another using only their arms. This is called brachiation, from the Latin word "brachium," meaning "arm."

Some of the physical traits that allow an orangutan like Suryia and Hanuman to swing by his arms include a short spine; short fingernails; long, curved fingers; and long forearms. Humans can imitate brachiation thanks to their flexible shoulders and articulated fingers, which are well suited for grasping.

Now you know why many children's parks include monkey bars. Children like to brachiate!

The apes weren't the only ones learning things. I was learning, too, fascinated to see how one ape could teach others how to swim.

Vali, a chimpanzee, saw Suryia swimming. Vali had played in the water before, but had never been able to move around as quickly as Suryia. He got curious to try it himself. Unlike orangutans, whose strength is in their upper arms, Vali's strength was in his lower body, which was built for knuckle walking on the ground. He didn't have the upper-body strength for swimming that Suryia had. To help little chimp Vali have fun in the water, my son, Kody, held him in his arms and showed him how Suryia swam, moving his arms in a windmill motion.

"We're gonna swim, too!" Kody told him.

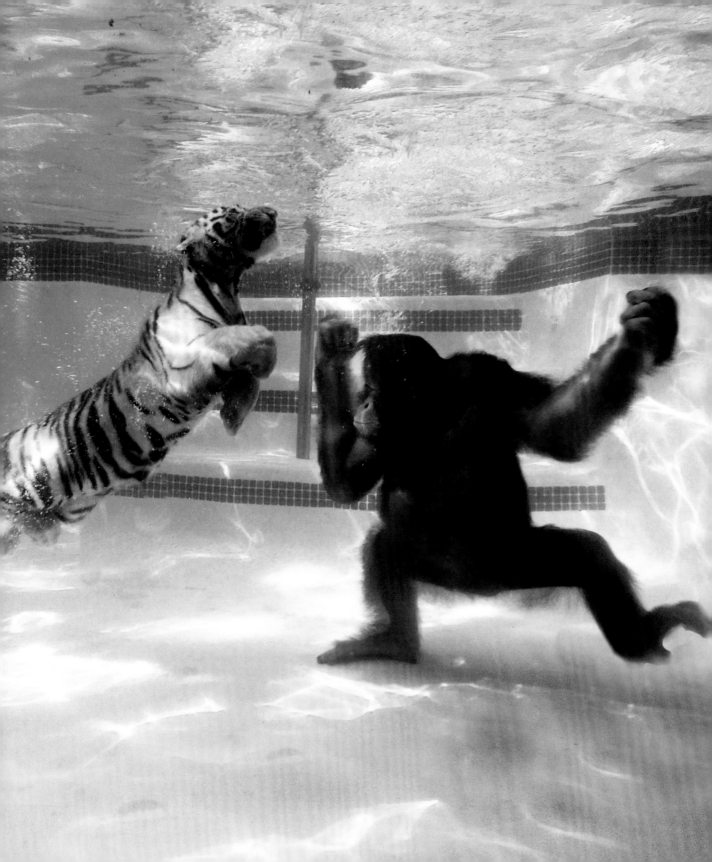

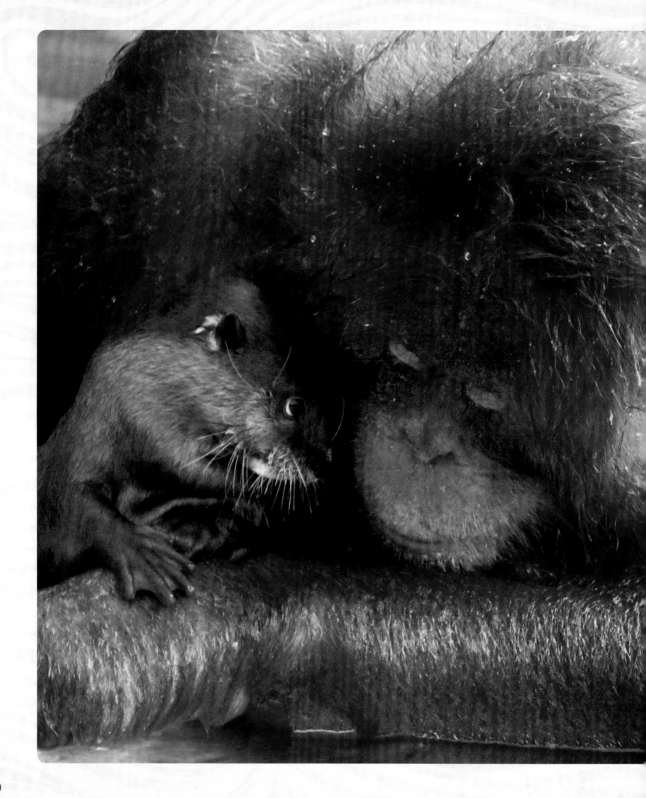

The staff stood at the far end of the pool, clapping and cheering Vali on. "You can do it!" we yelled out.

Vali began moving his arms up and down in a flying motion, pumping up and down, *flap-flap-flap*. Finally, when it looked like Vali was ready to take off, Kody put him in the water. Vali shot out—feet flapping, arms circling—and across the pool he went. He opened his big grinning mouth and whooped it up with a *"Chee-chee-chee!"* like he was saying, "I did it! I did it!"

We couldn't believe it. Another swimming chimp! Everyone picked him up and hugged him, cheering and clapping, and Vali pumped a fist in the air.

Chimp Rocky.

Suryia, Hanuman, and Vali—like other amazing animals at the Myrtle Beach Safari—teach us something important: When properly nourished physically and spiritually, living beings can do more than anyone expects. And we humans can become inspired to save these endangered species and heal the planet by their example.

Afterword

Thank you for spending some time reading about the animals residing at the Myrtle Beach Safari. In these stories, we've tried to convey that animals are sentient beings capable of thoughts and emotions. They care for offspring with just as much love as we do, and in a place like the Myrtle Beach Safari, that nurturing impulse doesn't just extend to babies of their own species. We are constantly amazed at how effectively an animal from one species will adapt his or her behavior to accommodate a relationship with an animal from another species and how close they can grow as friends.

How is this possible? It happens because here at our preserve, animals enjoy a nurtured, fulfilled life. They are less concerned with survival because their needs and security are provided by affectionate caregivers. This allows the animals' intellect and curiosity to grow.

There are consequences to not acknowledging this deeper, humanlike nature in animals. When we lose sight of the sanctity of life in all its forms, we run the risk of becoming inured to the pain we inflict on others. Indifference to the suffering of animals has led to the current crisis in wildlife conservation. Every day, dozens of species go extinct. Perhaps, it won't be long before tigers are nothing but a memory.

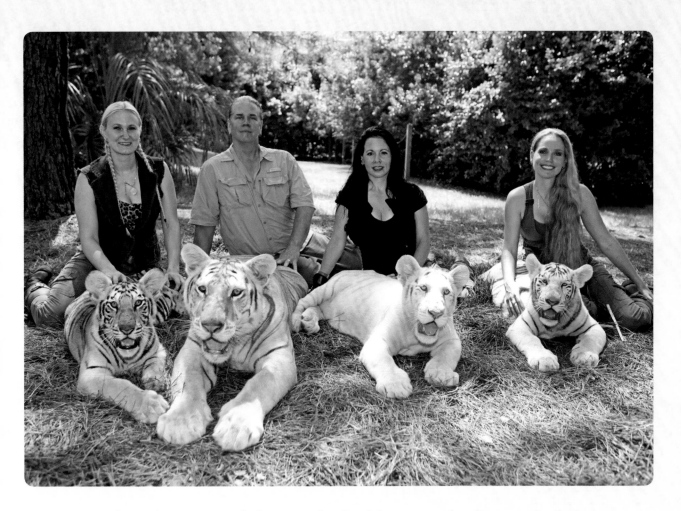

I hope the stories and photos in this book have stimulated you to think about animals and their ability to form meaningful relationships. We are privileged at the preserve to have close contact with so many intelligent, beautiful creatures. They enhance our appreciation for the magnificent world around us and keep us motivated to bring attention to conservation efforts.

These interspecies friendships are understood best when you can witness them for yourself. So, I invite you to visit us. We're open from April to October, by reservation. Just visit www.MyrtleBeachSafari.com and reserve your place. I look forward to welcoming you at the preserve and introducing you to our amazing animal friends.

EARTH AWARE
EDITIONS

PO Box 3088
San Rafael, CA 94912
www.MandalaEarth.com

Find us on Facebook: www.facebook.com/InsightEditions
Follow us on Twitter: @insighteditions

Library of Congress Cataloging-in-Publication Data available.

ISBN: 978-1-68383-130-3

Publisher: Raoul Goff
Associate Publisher: Phillip Jones
Art Director: Chrissy Kwasnik
Designer: Evelyn Furuta
Editor: Molly T. Jackel
Managing Editor: Alan Kaplan
Editorial Assistant: Tessa Murphy
Senior Production Editor: Elaine Ou
Production Manager: Sam Taylor

ROOTS of PEACE REPLANTED PAPER

Insight Editions, in association with Roots of Peace, will plant two trees for each tree used in the
manufacturing of this book. Roots of Peace is an internationally renowned humanitarian organization
dedicated to eradicating land mines worldwide and converting war-torn lands into productive farms
and wildlife habitats. Roots of Peace will plant two million fruit and nut trees in Afghanistan and
provide farmers there with the skills and support necessary for sustainable land use.

Manufactured in China by Insight Editions

10 9 8 7 6 5 4 3 2 1